BORROWER'S NAME

DATE

The
THREATENED
FLORIDA
BLACK BEAR

To my daughter, Marcia Clark Noel,
who cares for people and animals

PHOTOGRAPH CREDITS: Randy Cullom, 47; David S. Maehr, 2, 12–13, 14, 16–17, 22, 25, 27, 30, 33, 36, 38–39, 41, 52, 53, 56, 59; Stanford Noel, 55; Jayde Roof, 19, 20, 34, 42, 45, 50 (both).
Map on page 8 by Joseph Jakl.

Library of Congress Cataloging-in-Publication Data
Clark, Margaret Goff.
 The threatened Florida black bear / Margaret Goff Clark.
 p. cm.
 ISBN 0-525-65196-9
 1. Black bear—Florida—Juvenile literature. 2. Endangered species—Florida—
Juvenile literatre. [1. Black bear. 2. Bears. 3. Endangered species.] I. Title
QL737.C27C58 1995 599.74′446—dc20 94-48532 CIP AC

Published in the United States by Cobblehill Books,
an affiliate of Dutton Children's Books,
a division of Penguin Books USA Inc.
375 Hudson Street, New York, New York 10014

Designed by Jean Krulis
Printed in Hong Kong
First Edition 10 9 8 7 6 5 4 3 2 1

ACKNOWLEDGMENTS

In writing this book about the Florida black bear, I had help from many people. At the head of the list is David S. Maehr, Biological Administrator of the Florida Game and Fresh Water Fish Commission, who shared knowledge and incidents gathered from his years of study and experience with the Florida black bear. He also supplied many of the photographs on these pages. To be sure that the information in the book would be accurate, he read and reread the manuscript.

Defenders of Wildlife and Tom H. Logan, Chief, Bureau of Wildlife Research, helped in my search for material about the Florida black bear.

The following wildlife biologists contributed color photographs for use in the book: Jayde Roof, who also described the incident of the cabbage palm bear, and Randy Cullom, part-time worker with GFC.

I wish to thank my tireless editor, Joe Ann Daly; my helpful husband, Charles R. Clark; Clif Maehr; and my friends and fellow writers, Mary Kwitz, Claire Mackay, and Isabel Hobba, who gave me valuable suggestions.

CONTENTS

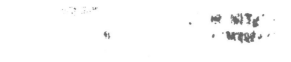

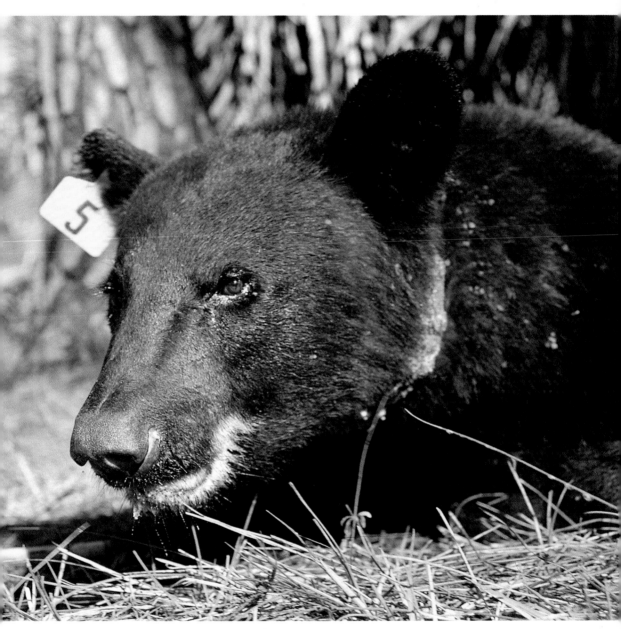

A young male bear wakes up after his capture in Collier County.

The THREATENED FLORIDA BLACK BEAR

Margaret Goff Clark

Illustrated with photographs

COBBLEHILL BOOKS Dutton New York

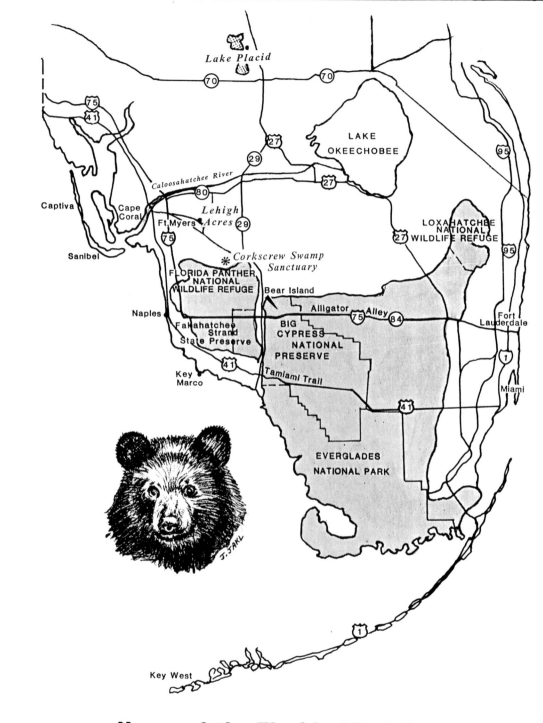

Lake Placid

70 70

75

41

LAKE
OKEECHOBEE

27

29

95

Caloosahatchee River

Captiva

Cape
Coral

80

*Lehigh
Acres* 29

Ft.Myers

75

Sanibel

LOXAHATCHEE
NATIONAL
WILDLIFE REFUGE

27

95

*Corkscrew Swamp
Sanctuary*

FLORIDA PANTHER
NATIONAL
WILDLIFE REFUGE

Bear Island

Naples

Alligator 84 Alley
75

Fort
Lauderdale

Fakahatchee
Strand
State Preserve

BIG
CYPRESS
NATIONAL
PRESERVE

1

Key
Marco

41

Tamiami Trail

41

Miami

EVERGLADES
NATIONAL PARK

J. JAKL

1

Key West

Home of the Florida black bear

INTRODUCTION

LIKE THE FLORIDA PANTHER, THE FLORIDA BLACK BEAR IS THREATENED BY human population growth and the development that goes along with it. But unlike panthers, black bears are still found throughout the Sunshine State. Sightings in the suburbs of Naples, Lake Placid, Ocala, Panama City, and Jacksonville attest to the black bear's adaptability, as well as to the widely distributed habitat that is needed for Florida's largest land mammal. These sightings, as well as recent studies, also suggest that black bears in Florida can be wanderers, occasional nomads across a quickly changing landscape. How much longer will these travels be possible?

Most residents in Florida are not even aware that bears inhabit their state. But just like black bears throughout North America, there are more black bears in Florida than most people recognize, responding to the seasonal changes that drive their travels through many of Florida's forests. From the Everglades to Georgia, and from the Atlantic Ocean to the Gulf of Mexico, bears live their lives

feeding on the rich bounty of plant life that is fueled by warm temperatures and abundant rainfall. And hibernation (yes, even in subtropical south Florida) helps growing families survive until the pulse of new growth begins again each spring.

There is little assurance in many parts of Florida that these annual bear cycles, evolved over thousands of years, will continue much longer. Education is always the first step in making wise choices concerning our environment. As our youth increase their awareness of the world around them and appreciate the direct links between healthy wildlife populations and the quality of their own lives, the prospects for species like the black bear improve. *The Threatened Florida Black Bear* can provide a foundation of awareness for young Floridians, and increase the chances that black bears, a healthy environment, and people will always be a part of the future.

DAVID S. MAEHR
Biological Administrator
Florida Game and Fresh Water
Fish Commission

1

THE TRAVELS OF
BLACK BEAR NUMBER ONE

IT WAS LATE APRIL WHEN THE CALL CAME TO THE OFFICE OF THE FLORIDA
Game and Fresh Water Fish Commission. "What are you going to
do about a chicken-stealing bear?" The voice on the telephone was
angry.

David Maehr, a wildlife biologist with the Game and Fish Com-
mission, took the call. "What makes you think a bear is the thief?"
he asked.

"I have plenty of evidence!" was the reply. "Come see for your-
self."

In the backyard of the home in Collier County in southern Flor-
ida, Maehr saw a damaged chicken coop surrounded by bear tracks.
A trail of white feathers led to a woodland area nearby.

Maehr smiled and told the resident, "You're right."

On April 30, David Maehr set five snare traps around the yard
and after that checked them every day. These traps, called leg-hold
snares, work by putting a cable around a bear's leg. They are strong

enough to hold a large animal without serious damage to it. On May 4, only four days after setting the traps, the biologist found he had caught a black bear, a male, weighing about 200 pounds. The bear was angry, but not injured. Using a long pole tipped with a syringe containing an anesthetic, Maehr put the bear to sleep. While it was unconscious, he checked for injuries or illness, then weighed and measured him and fastened a radio collar around his neck. Maehr named him Male Number One, or simply M1. If it had been a female, it would have been labeled F1.

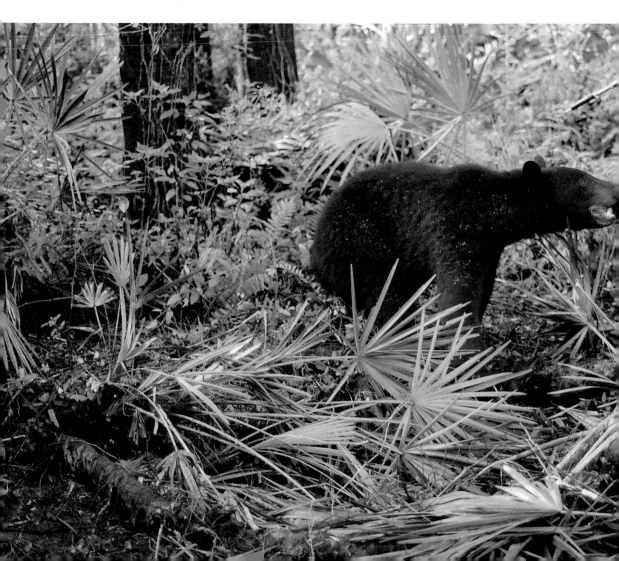

This type of work was not new to David Maehr, for he had been a leader in the Florida Game and Fish Commission's study of the endangered Florida panther. The black bear had been studied in central and northern Florida ever since 1978, but this was the first one to be collared in southwest Florida by a member of the Game and Fresh Water Fish Commission.

In 1991, when the Commission began to do research on the black bear in south Florida, four biological researchers headed the program. Darrell Land and Walt McCown did most of the locating

A young male bear caught with a leg-hold snare gets injected with a tranquilizer.

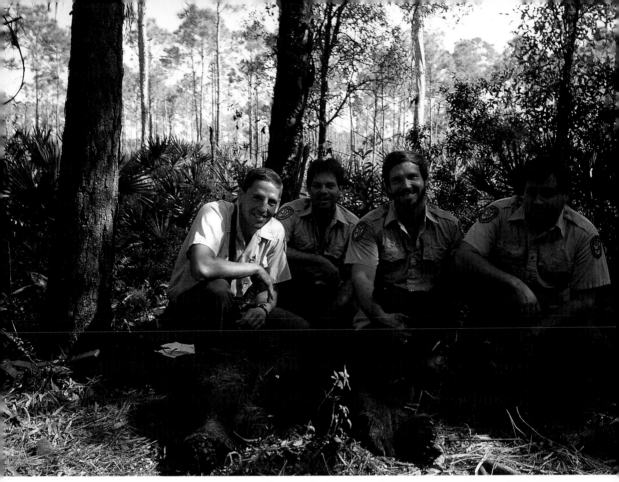

These researchers captured over 60 bears in Collier County from 1991–1993.
Left to right: David Maehr, Darrell Land, Jayde Roof, Walt McCown.

of radio-collared bears, tracking them from an airplane 500 to 1,000
feet above the ground. On the land below, David Maehr and Jayde
Roof were in charge of trapping and examining the bears.

Maehr knew it was not likely that Bear Number One would return
to this particular spot again, for bears rarely went back to places
where they had been trapped. But as the bear trotted away into
the woods, Maehr knew he could be tracked wherever he went,
since he now had a radio collar. With the help of other members
of the Game and Fish Commission, the biologists hoped to find

the answers to many questions about Florida black bears, such as how their health could be improved and why their numbers were becoming fewer.

Bear Number One started on a long, adventurous journey by wandering into a cypress swamp not far from the chicken coop. After that, the biologists found him near several homes and bee yards. His first stop was at Corkscrew Swamp Sanctuary, an Audubon Society nature center where there was a boardwalk for viewing the swamp, but nothing to eat. Bear Number One looked around and did not stay long.

When he came to Lehigh Acres, several miles away, he had no use for the growing town with its many scattered houses. It was the nearby bee yard that he liked. He charged in and ate honey and bees until full, and lingered for seven or eight days.

When he left the bee yard, the 195-pound, two-and-a-half-year-old bear traveled north about 84 miles from June 7 to July 2. He went through suburbs where many people lived, crossed busy highways, and even the deep Caloosahatchee River. Finally, he reached the Archbold Biological Station near Lake Placid in Highlands County. While he was in the Lake Placid area, he met a companion. In that region, biologist James Layne found bear footprints near those of Number One, but smaller than his. They were the right size for an adult female. Perhaps Bear Number One had found a mate.

All through this trip the Florida Game and Fresh Water Fish Commission received no reports or complaints from the people who lived along the route of the wandering bear. This was surprising, since Bear Number One had been near many people and had raided at least one bee yard along the way.

Something else puzzled the biologists. The Caloosahatchee River

Adult male bear M3 walks around a swamp in the Fakahatchee Strand State Preserve.

crosses Florida from east to west, from Lake Okeechobee to the Gulf of Mexico. Although the GFC people had kept close watch of the bear, they had not seen him crossing the river. He had to have crossed in some way because he had reached Lake Placid which was on the north side of the river. Did he swim over or had he followed the shore until he came to a bridge and then walked across?

The researchers who were tracking Bear Number One were surprised that he traveled so far. This was of special interest to David Maehr. Because of the rapid increase of people, bears had

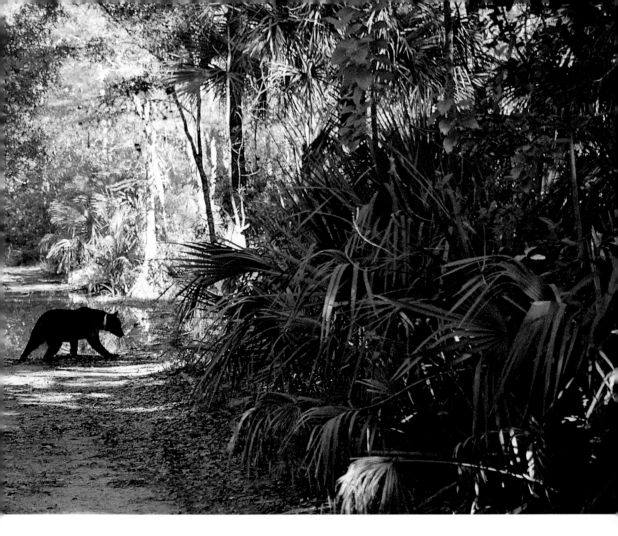

been forced to live in smaller groups scattered around the state. Surrounding the groups were houses, farms, and busy roads. Maehr feared this might cause bears to stay in one place and mate only with those in their own group. This could bring about inbreeding (mating with relatives), and the bears might have unhealthy cubs.

Number One's long trip gave the researchers hope. If one bear could leave his group and walk through populated areas new to him, perhaps other bears would also travel, mating with bears in other groups. This would be good for the health of Florida's baby black bears.

2
BEAR HISTORY

ACCORDING TO THE AMERICAN MUSEUM OF NATURAL HISTORY, THE FIRST bear lived about 20 million years ago. It was the size of a small dog. Today, there are eight species of bears worldwide. They are: polar bear, grizzly bear, Alaska brown bear or Kodiak, American black bear, spectacled bear of South America, Asiatic black bear, Maylayan or sun bear, sloth or Indian bear.

The Florida black bear is recognized as a subspecies of the American black bear and has the scientific name of *Ursus americanus floridanus*.

The bear family is most closely related to the canid family, which includes dogs, wolves, foxes, and coyotes. Looking closely at a black bear's nose, one can see that it is similar to the nose of a wolf and some kinds of dogs. Another sign of their relationship is that a bear cub in play often takes the nose of another young bear gently in its mouth, just as wolves do.

Before the coming of people from Europe to America, black

bears were found throughout the northern hemisphere. There were also polar bears, grizzly bears, and brown bears, but the black bear was the most plentiful and most widespread.

The Indians, who were here long before the Europeans came, honored the bear. Many believed it could cure disease, and others thought it was related to man. Perhaps this was because bears walk flat-footed and can stand up on their hind legs, as man does. Although they respected it, the Indians killed the bear, apologizing to it as they shot it down with their arrows. They did not kill it for

This bear cub was too small to be radio-collared, but was tagged.

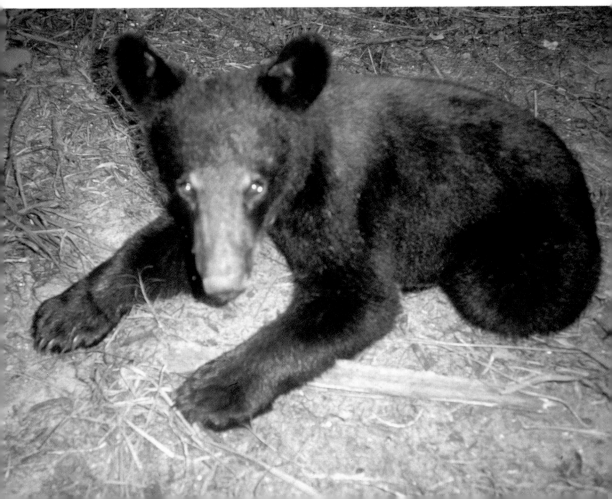

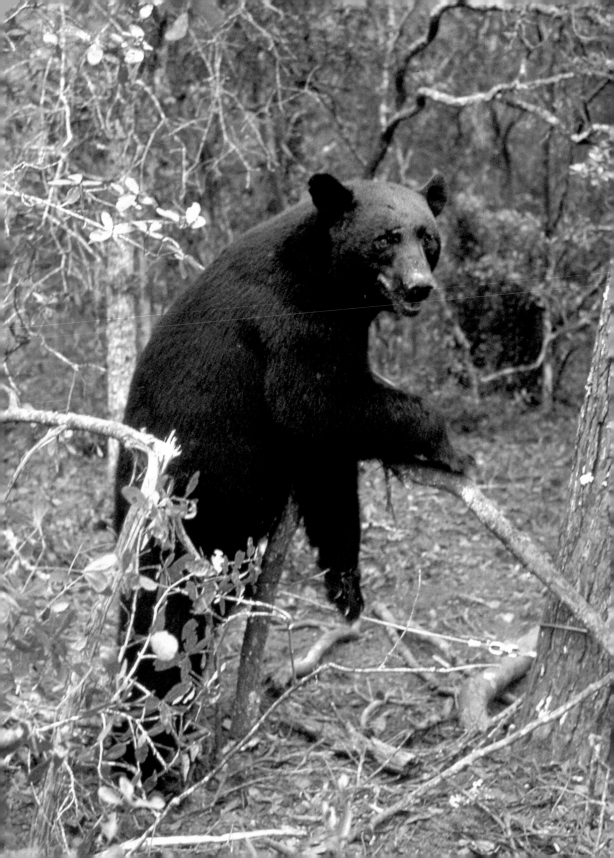

pleasure, but made good use of the body, eating the meat, cooking with the oil, and rubbing it on their hair. The bear's skin with its thick fur made warm blankets and coats.

The Indians were wise about conserving wildlife. They were careful not to kill too many bears in any one area. Also, they did not destroy the forests. This made it possible for bears to continue to live and eat in peace with the Indians.

In Barbara Ford's book, *Black Bear: The Spirit of the Wilderness*, she reported, "When naturalists John and William Bartram explored the wilderness that was Florida in the 1770s, they saw eleven bears in one day." In those times Florida's forests covered the state and provided homes and food for large numbers of black bears. When settlers poured into the state, they began to cut down the trees and clear the land for farms, houses, and roads, taking away the bears' homes and the wild berries, nuts, grasses, and herbs that were their foods.

Before long the bears discovered that the newcomers' vegetable gardens and fields of corn were full of food even tastier and easier to find than wild plants and berries. But they soon learned there was a heavy price to pay for this easy food. Angry farmers chased them away with dogs and guns. The settlers thought of bears as vermin, creatures that deserved to be killed, and so hunted them freely. The forest was no longer the bears' peaceful home.

For many years bears had no protection in Florida, but in 1950 they were given the standing of a game animal with a legal hunting season at the same time as the deer season. In 1971, the bear hunting season was closed all over Florida, except in Columbia

Bear Number 8 caught in a snare trap.

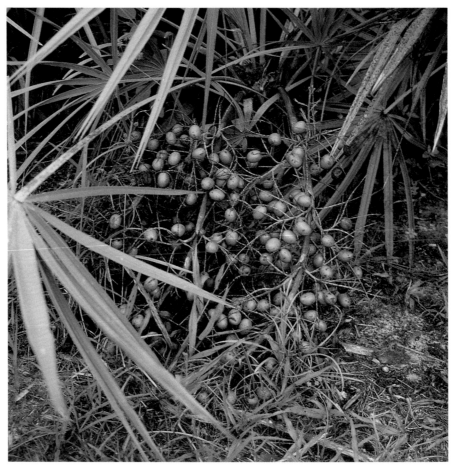

The fruit of the saw palmetto is one of the black bear's foods.

and Baker counties and in the Apalachicola National Forest. In 1974, the Florida black bear was listed as a threatened species, except where it occurred as a game animal. When an animal is listed as "threatened," that means its numbers are becoming fewer and that it needs protection and help before it is too late. This is the last stage before being listed as "endangered."

An endangered animal has so few of its species left, it is in danger

of becoming extinct. If it becomes extinct, it will be gone forever. The U.S. Fish and Wildlife Service and the wildlife biologists with the Florida Game and Fresh Water Fish Commission are working to keep the Florida panther and the Florida black bear from vanishing.

Hunting became a controversial issue during the 1980s. Many people objected to the fact that an animal listed as threatened could still be hunted, even in relatively small areas. In 1993, the Florida Game and Fresh Water Fish Commission closed the bear hunting season throughout Florida.

3
HIBERNATION

DO FLORIDA BEARS HIBERNATE? EVEN AMONG RESEARCHERS WHO STUDY the bear, there are different opinions.

David Maehr believes they do hibernate, but not exactly the way their northern relatives do. Like other bears, Florida black bears start to prepare for hibernation in late summer or early fall by eating all the time. They seem to try to put on as much fat as they can to carry them through the winter.

In September, October, and most of November, they feast on the fruit of the saw palmetto, a low-growing palm that is common in the southern United States. To humans the small, rounded black fruit tastes terrible. The bears seem to like it, but as soon as the acorns are ready, they become their favorite food.

The bears keep on eating whatever they can find until the end of December when they are ready for their winter rest. Even in south Florida, bears make winter dens, but most of them do not

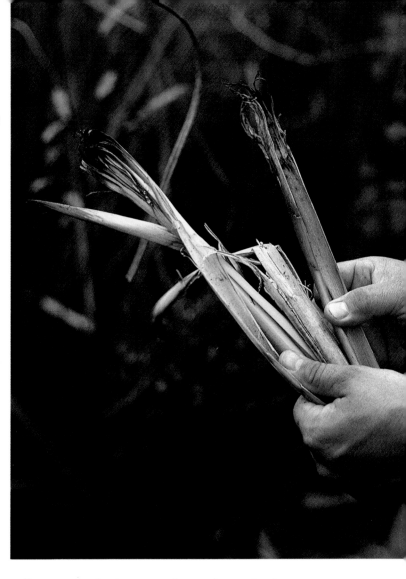

During winter, black bears will eat the stems of saw grass. These chewed stems were found at a male bear's winter den.

crawl into a cave or a well-protected place to sleep through the winter as northern bears do.

Some biologists are not sure if the southern bears really hibernate. Bears in Minnesota, Canada, or the Adirondacks of New York State like to settle down in a cave, a cleft in a rock protected by a wall of snow, a hollow tree, or a deep hole dug in the ground. They may stay for as long as six months.

A Florida bear may choose to curl up in the shelter of a hollow

25

cypress stump two or three feet high. One daring female bear spent the winter perched on the flat top of a stump and actually raised her cubs on this dangerous perch.

David Maehr says, "We found places where a male bear had mashed down ferns and saw grass and had made a big den that looked like a giant robin's nest. The bear might spend two or three winter months there, or only a few days. In Florida about all bears have to worry about is a cold front or rain. They just curl up in a ball and take it, I guess."

J. B. Wooding, who has spent a great deal of time studying the black bear, says, "The only true hibernators among Florida bears may be females having cubs." As if to prove this statement, a radio-collared female that gave birth to cubs in January, 1987, stayed in her nest from late December, 1986, until April, 1987. However, other observers have noticed that many males also hibernate.

Two wildlife biologists, M. A. Ramsey and R. L. Dunbrack, suggest that hibernation helps to give a mother bear the strength she needs for having cubs, nursing them, and taking care of them until they are able to care for themselves.

When bears hibernate in temperate regions and farther north, people who study them have discovered that these slumbering creatures usually not only have lower body temperatures and slower heartbeats, they do not eat or drink. Also, they do not urinate or defecate. This is true hibernation.

Although many Florida bears may spend part of the coolest months in their dens, it is warm enough for them to wake up now and then to stroll around and eat whatever they are able to find. Some show the same deep inactivity displayed by bears up north, yet it is easy to rouse them at any time. This is one reason it is difficult to study the condition of Florida black bears. They are

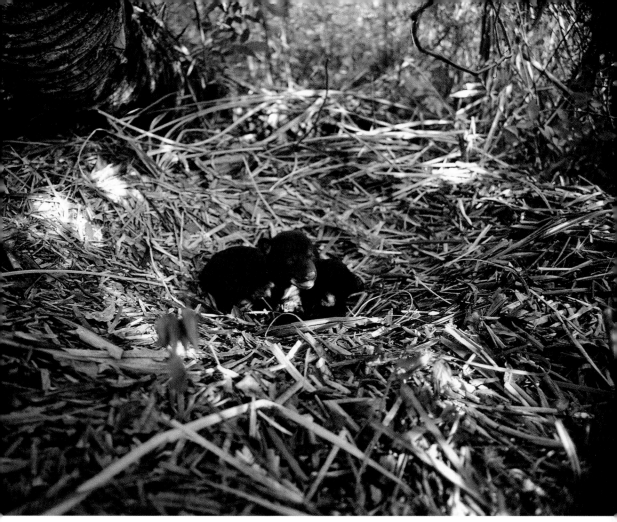

These two cubs, about two weeks old, are in their winter den, a nest on the ground.

light sleepers. A bear that is even half-awake will not hold still to have its temperature taken.

Maehr explained, "We suspect there are some physiological changes taking place in them, but we don't know exactly what they are. We don't have the luxury of crawling into an icy den or cave. Biologists often do this in the Smoky Mountains of Tennessee or up in Minnesota where the bears are so sound asleep the re-

searchers can actually handle them. In Florida, if we try to do that, they get up and run away from us."

Northern bears are often much thinner when they leave their winter dens. In Florida, the bears lose less weight. Perhaps this is because of the warmer temperatures which make it possible for some foods to grow and encourage those winter snacks.

4

BLACK BEAR CUBS

DURING THE WINTER, RESEARCHERS WHO STUDY FLORIDA BLACK BEARS KNOW where to find them, because they are almost always sleeping or resting in their dens.

By late spring, the bears are fully awake, and from then on through the fall months, they move around, going from place to place, looking for food and mates. This is the time of year when the female bear becomes pregnant, but the baby bear does not begin to develop at once as it does in most mammals. Instead, it is the nature of bears that the baby does not grow inside the mother until she retires in her winter den. Because of this, the pregnant female is free to travel and eat during the summer and fall. This works well for her. When it is time to hibernate, she is healthy and has stored up enough fat to last through the winter and still have enough to make milk for her cubs when they arrive.

The last week in February or the first week in March appears to be the most popular time for the cubs to be born in south Florida.

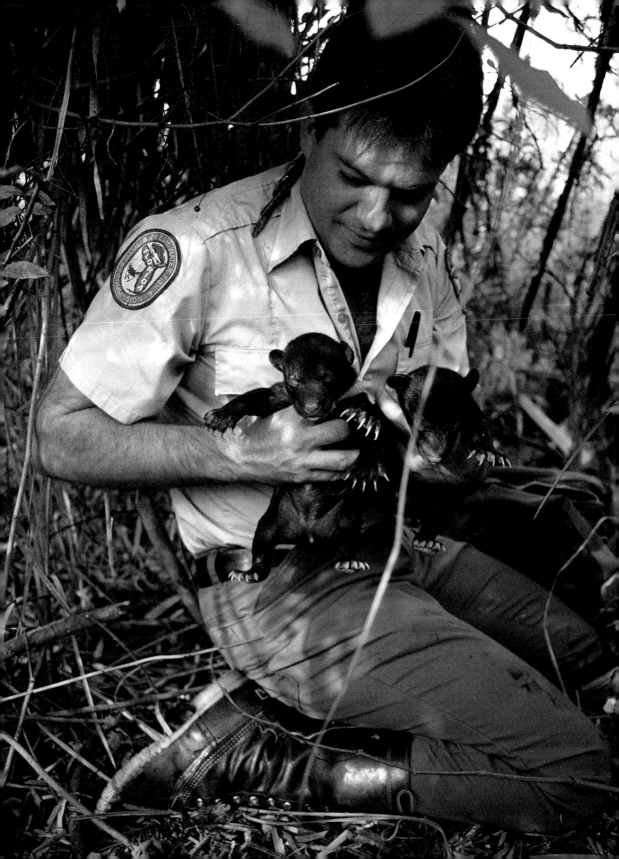

David Maehr commented, "It almost seems as if someone rings the bell and they all give birth. Within a two-week period, as far as we can tell, all the females give birth to whatever cubs are going to be produced in that year."

The size of the litters ranges from one to three. Often there are twins. The newborn cubs are helpless and their eyes are closed. They weigh less than a pound and are about the size of a small squirrel. Their fuzzy hair is so short and thin it is almost invisible.

Although they cannot walk, they manage to crawl to their mother's side and begin nursing. They often make a contented, purring sound while they drink. By one week of age they are climbing all over their mother. When they are two weeks old they are still nursing, but their fur is becoming thicker, making them look more like toy black bears.

David Maehr observed, "For a solid four months, at least here in southern Florida, the mother bears are denned up, and for at least half of that time they're nursing their cubs with very little additional nutrition. They're doing all of this by using their fat stores."

The mother's den may be no more than a hollow tree or a circle of grass and leaves, but it still is called a den.

The GFC biologists spend a great deal of time studying the way the bears live. The more they learn, the better able they are to understand the needs of these threatened animals. The biologists can go closer to wild animals, such as the panther and bear, than is safe for other people. One reason for this is because, by working with animals, they know what to expect. Even so, they, too, are

Darrell Land examines the cubs of female bear F6 in Collier County.

often in danger. It is not possible to know what a wild animal may do. David Maehr's son, Clif, went with his father when Maehr was called to care for a trapped bear, but Clif petted the bear only when it had been given an anesthetic.

One morning in April, Darrell Land, Jayde Roof, and David Maehr went out in a pickup truck, as they often did, looking for collared female bears that they knew were in their dens. The habit of the researchers was to drive near to the den and then get out and walk the last two or three hundred yards.

From past experience, they were sure that when they were close, the female would get up and walk away. Then they could pick up the cubs, measure and photograph them, describe the location of the den, study the plants around it, put the cubs back, and leave. After that, the female would return.

Already this morning they had lcoated two dens. In both, they had found two cubs, a male and female, each weighing two pounds. After photographing the dens with the cubs inside, Maehr had snapped a picture of Darrell Land holding two of the little ones.

There was another den the biologists hoped to find. Signals from the female's radio collar had showed she was not far from where they were. They also knew she was Female Number 3. Just as the men hoped, they were soon in the area, but a canal blocked their way. They parked the truck, then plunged into the canal and struggled across in water up to their waists.

When they reached the far side, they were in a swamp with scattered trees of cypress, red maple, cabbage palm, and laurel oak, tangles of vines, and ficus, the native fig tree.

The researchers knew this was an ideal place for a den. The female bears liked plenty of cover to hide their little ones.

"What do you think, Darrell?" asked Maehr.

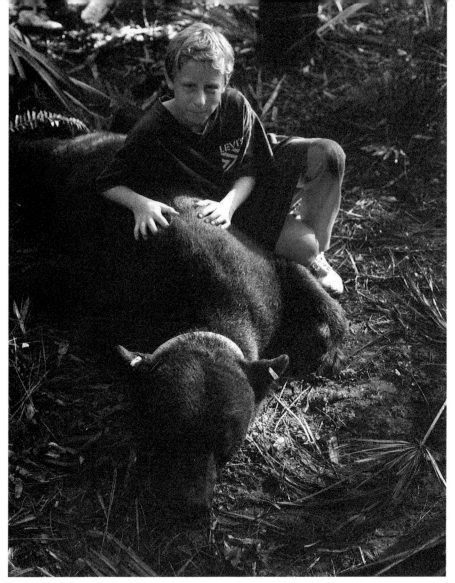

David Maehr's son, Clif, knows that it is wise to pet a bear only after it has been tranquilized.

Darrell Land, who had acute hearing, was often the first to hear the chatter and squeak of the cubs. He pointed ahead, and splashed through the water and undergrowth toward a large hollow cypress stump.

33

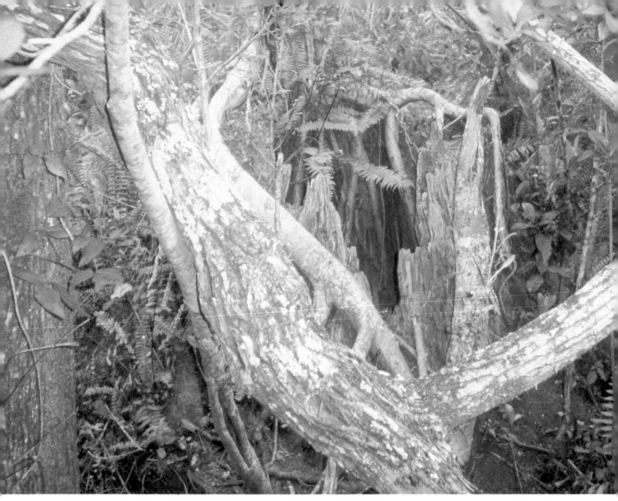

The cypress stump that Darrell Land stuck his head into while the female was still there with her cubs.

Jayde and Maehr stayed where they were, waiting for Darrell to lean over and lift out the cubs. Instead, he gasped and jumped back.

"She's still there!" Darrell hurried toward the other two men, wiping his forehead on his sleeve. "What a shock! I was ready to pick up a two-pound cub and I see a two hundred-pound female in there."

The men stood motionless, their eyes on the stump. No black

34

head appeared above the rim, and in the silence they could hear the faint purr of a cub nursing.

After a few minutes the biologists could no longer resist creeping to the edge of the hollow stump. The female bear was curled on her side. Her head was up and her eyes looked straight at the men. She did not make a move. Neither did the two cubs that were nursing beside her.

The biologists made notes of what they had seen and returned to the truck. In the following weeks they monitored the mother bear and her babies in the cypress stump. They continued to keep track of them as the cubs grew, to find out if they were developing in the usual way.

The biologists knew that when bear cubs are four months old they begin to look around outside the den. However, they stay close to their mother and continue to nurse for a few more months. The father of the cubs does not take any part in caring for them.

When a cub is lost, it whines and cries until its mother locates it and pushes it back to its brother or sister. By staying near their mother, and watching her, bear cubs find out what foods to eat and learn that they must stay away from people, panthers, and adult male black bears because they might attack the little ones.

In the spring the young bears eat grasses and plants. Before long they add berries, grasshoppers, ants, bees, and insects they can find under rocks or in rotted logs. Black bears are omnivorous— that is, they will eat almost anything—but they seem to prefer vegetation, berries, and nuts whenever they are available.

While still very young, bears climb trees with the help of their strong, curving, sharp claws. Often, several young bears will climb the same tree and use it as a playground. For the mother, the tree is a silent cub-sitter. Even when they are older, bears will run up

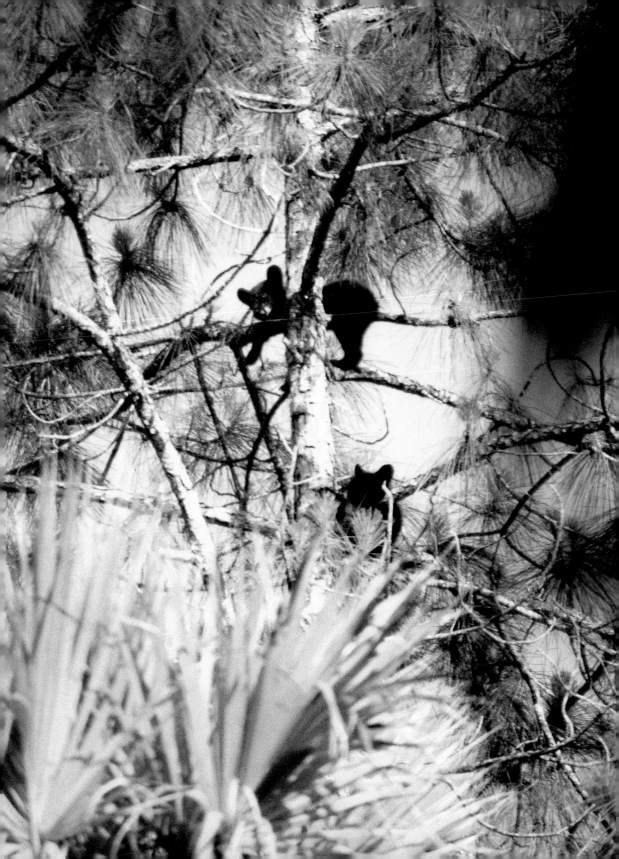

a tree when they are in danger. They climb up headfirst, but when they leave, they back down the trunk, hind feet first.

When the cubs are yearlings, one and one half years old, their mother leaves them and starts to look for another mate. Sometimes a cub stays with a brother or sister, but by the next spring they usually have separated.

The yearling male bear looks like a smaller version of his father. His black hair is shiny and thick, his snout is tan-colored, and his round ears stand upright. His eyes, gentle and questioning, give away his youth. He often has a hard time. He has to look for a range of 50 to 200 square miles where there is plenty of food and possibly a female or two nearby. Just as he finds a satisfactory range, a full-grown bear may rise up in front of him, letting the young bear know the land is taken.

The young female usually has an easier time than her brother. She needs less land. A home range of from 10 to 20 square miles is large enough for her, and she may even be able to stay near her mother. The young female is smaller than her brother and looks like her mother.

All young bears have to be on the alert to keep away from adult male bears. The male yearling is in more danger from them than his sister. When their mother is around, she chases the big bears away from her cubs. Occasionally the father bear will attack one of his cubs, but this does not happen often.

The three biologists took turns checking on the development of Female Number 3's cubs found in the cypress stump, and were

Two young cubs seek refuge in a pine tree in Collier County.

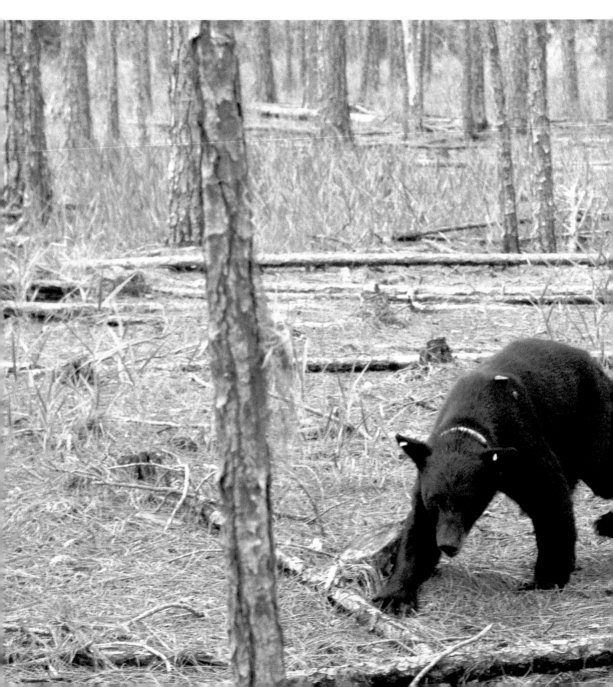

THE THREATENED FLORIDA BLACK BEAR

pleased with their progress. David Maehr remarked, "If these two young bears are wise and lucky, they may live to be from 15 to 20 years old."

Young bears have to find their own range areas.

5
THE FLORIDA
BLACK BEAR

THE AMERICAN BLACK BEAR IS THE SMALLEST AND THE MOST PLENTIFUL KIND of bear in the United States. The Florida black bear is a subspecies of the American black bear, with a shiny black coat and a white patch on its chest. Its light brown snout is straight, and the short tail is almost out of sight in its long fur. The bear is five to six feet long and about three feet high at the shoulder.

Most of the time the Florida black bear has a thick, black coat like that of its northern relatives, but in the summer, if the weather is hot, some of the Florida bears shed their black guard hairs. Then they show the woolly brown fur underneath. During the winter, the black hairs grow back. In the northern states the bears' glossy coats remain about the same thickness all through the year.

There is a biological pattern called Bergman's rule which, simply worded, states that an animal in the south does not have to be as large as the same kind of animal in the north because it does not need as large a body to conserve heat. How does the size of the

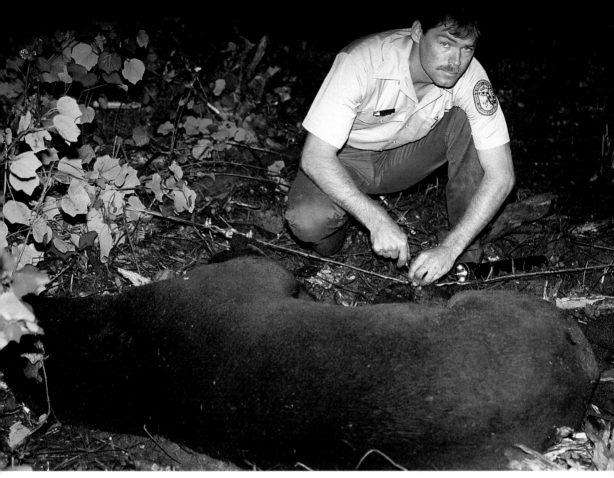

Biologist Jeff McGrady with a large male bear that has lost many of its black guard hairs.

Florida black bear compare to a northern black bear? If it follows Bergman's rule, it must be smaller.

When David Maehr was asked how the size of the Florida black bear compared with northern bears, he answered, "Pretty favorably. In fact, on average, our bears may be larger than black bears in other parts of the country." Maehr believes Florida bears may be large because the growing season there is long and many of the bears are active and eating most of the year.

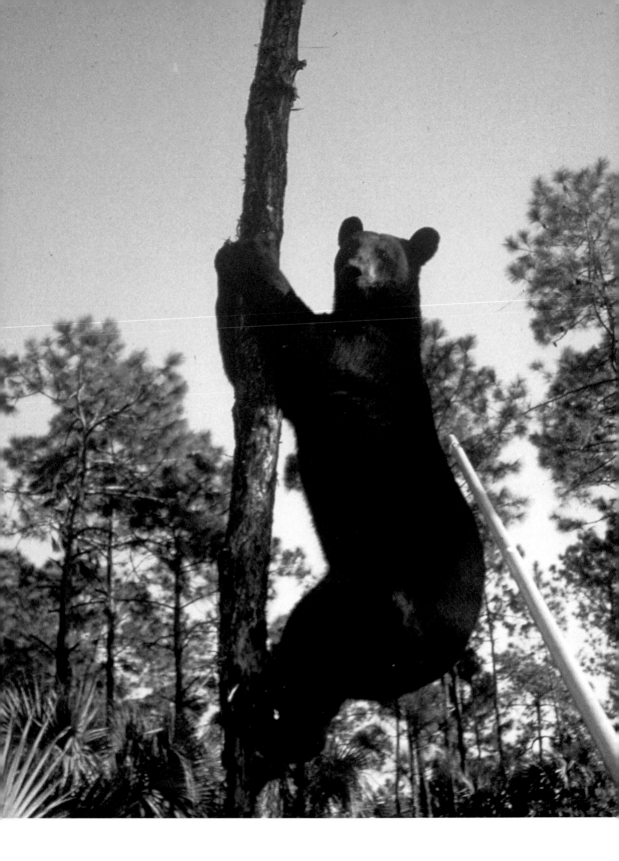

According to Maehr, adult female black bears weigh from 150 to 300 pounds, while male bears range from about 250 to 600 pounds. Male bears have a wider range in weight because as they grow older, they go down in weight and size. They are also more likely to wander farther and cross roads more often than the female. Because of this, they have a greater chance of being injured.

Although they have more injuries, the male black bear generally lives longer than the female. This may be because he has only to look after himself. The female seems always to have work to do. She becomes sexually mature when she is two to three years old and gives birth to a litter of cubs every other year. Besides nursing and protecting them while they are young, she is their teacher, showing them how to live when they leave home.

In spite of their problems, Florida black bears, both male and female, are usually strong, healthy animals. They rarely are sick, and when injured, they generally heal well.

The Florida black bears usually stay by themselves and do not bother people unless they are attracted by food. There has never been a report of a Florida black bear attacking a human.

This bear up a tree is being tranquilized with a syringe on the end of a pole.

6

THE CABBAGE PALM BEAR

IT WAS SPRING IN SOUTHERN FLORIDA. THE BLACK BEARS HAD BEEN SLEEPING on and off during the winter, not eating very much. In the winter, food was scarce, even in the Big Cypress Swamp.

Now that it was late April, the bears were wide awake and hungry. They craved fruit, juicy berries, or acorns, but it was too soon for any of these. As a result, they ate anything that was green, such as weeds and the buds and stems of saw grass, a kind of herb that is plentiful in the Everglades and other marshy places.

Jayde Roof, one of the wildlife biologists with the Game and Fish Commission, was out enjoying the spring day, but also interested in seeing what some of his study animals were eating.

Suddenly, a crashing noise to his right, on the far side of a dense cluster of bushes, brought him to a halt.

The sound continued. To Jayde, it was as if something were being torn apart. As he listened, he clearly heard a grunt, followed by another ripping noise. Seconds later, Jayde picked up the signal

Cabbage palm with the heart pulled out by a bear wanting the tasty morsel.

from a bear's collar. For a few moments he had considered pushing his way through the clump of bushes to find out what was happening. Now he gave up the idea. He had his radio equipment and

he knew the bear that was on the other side of the bushes. It was black bear Number M3, and he weighed about 350 pounds.

The crashing and grunting sounds seemed to go on forever. The bear must be tearing a tree apart.

Jayde was familiar with the sturdy cabbage palm tree of southern Florida. It was seven feet high and at least four feet around the trunk. Now it sounded as if the bear was pulling off the palm fronds. Jayde knew what the bear wanted. At the top of each cabbage palm tree is a bud and in the center of the bud is the heart of the palm, a delicious morsel which has a much better taste than the palm's fruit. Its taste is so good, in fact, that people buy this delicacy in grocery stores. The heart of palm is often cut into bite-sized chunks and used in salads. In LaBelle, Florida, this popular food has for years been featured at the annual Swamp Cabbage Festival.

The noises went on and on while Jayde waited. When at last they stopped, he started cautiously through the bushes, moving the branches away with care and setting each foot down gently like a stalking cat. Finally, he could see daylight ahead.

The sight he faced took his breath away. To Jayde, it looked as if a tornado had passed through. The bear was gone, leaving what was left of a large cabbage palm tree standing at an angle. Palm fronds littered the ground. The bear had torn away more than half of the tree.

Jayde's eyes traveled up the skeleton. At the very top there was an open space where the bud of the palm should have been. Jayde had seen men with axes strain to reach the heart of a cabbage palm, but this bear had done it alone, with no tools but his claws and his amazing strength.

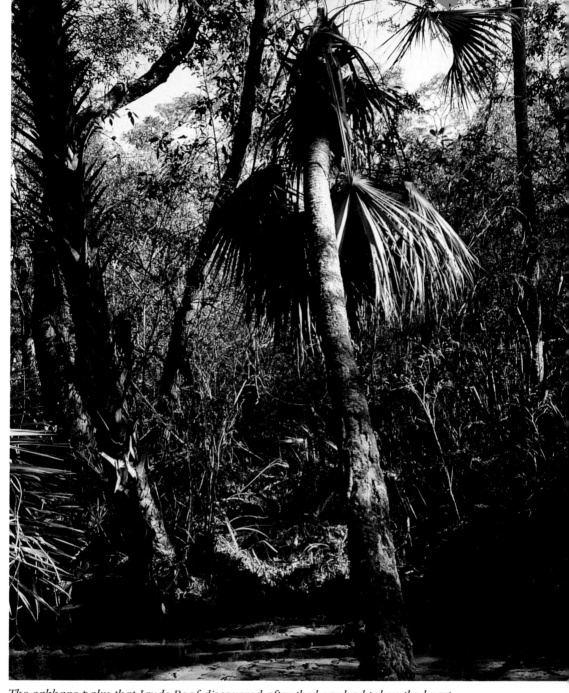

The cabbage palm that Jayde Roof discovered after the bear had taken the heart of the palm and departed.

7

A BEAR'S BEST FRIENDS

IT WAS 6:00 P.M. AND DAVID MAEHR WAS HOME AND ABOUT TO HAVE DINNER when the call came.

"There's an injured female bear lying in the road," said the voice on the phone. "She was hit by a car. I don't know how bad off she is. Will you help me check her out?"

Maehr took down the location of the bear, then went to meet his colleague, biologist Jim Schortemeyer. It would take both of them to handle the bear.

It was the middle of December and it was already dark, but the men knew the area well. When they reached the place described by the caller, the large female bear was lying on the side of the road. Her rear was in a roadside ditch which was full of water and her upper part was on the grass. She was stunned, but she was not dead. Her eyes stared up at the men. She was not wearing a radio collar.

48

Maehr injected drugs to make her safer to handle, then he and Schortemeyer pulled her out of the water and knelt to examine her. They soon discovered that the upper part of her right leg was broken and she had a broken jaw. There was no way they or anyone else could repair the jaw or set the leg of a large wild animal like this. Besides, a bear would not put up with having a cast on its leg and would pull it off.

Maehr knew of another bear that had had a broken leg a few years ago. It had taken care of itself, and in thirty days the break had healed and the bear had gained fifteen pounds. The researchers knew it was generally better to let a wild animal like this heal itself.

Across the road from the bear was the Copeland Road Prison, a minimum security facility, at the edge of a forest. The guards stationed near the road had been watching what was going on and told Maehr and Schortemeyer that three cubs were waiting for their mother, the injured bear, to return to them. The prison guards showed the biologists a path into the forest that the young bears frequently traveled.

One of the guards said, "You could pull the mother bear over here where she would be safe and closer to her cubs." He pointed to a big tree a short distance down the path. "There's where those cubs spend a lot of their time."

Knowing how important it was to keep the mother and cubs together, Maehr and Schortemeyer were glad to take the guard's advice. They put a radio collar on the injured bear, now known as F21, and left her at the edge of the woods along a well-used trail. From then on they kept track of her with the help of her radio collar and by making frequent visits to check on her. During this time the female rested while her cubs continued to feed on acorns near the prison's entrance. At the end of the month she had healed

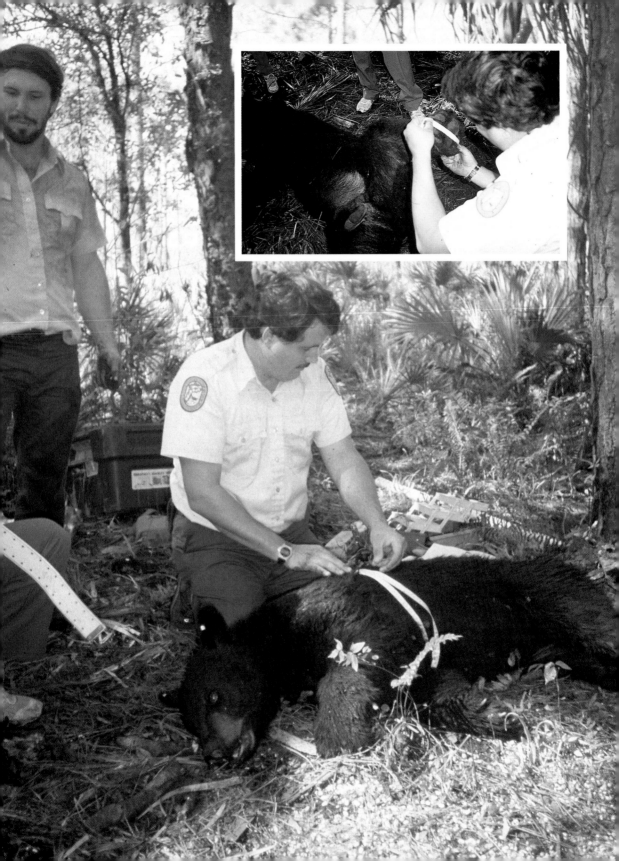

and was moving around with her cubs once again. She was on all four legs.

During their years of studying Florida's animals, researchers have collected a great deal of knowledge about the way wildlife lives and what is needed if the animals are to maintain healthy populations.

Bears in Florida are now living on small patches of land. Because of this, many are killed by cars while going from one section of land to another for food and mating. Researchers believe that bears would be safer and less likely to suffer inbreeding if their patches of land were connected by strips of forest or undeveloped land. They could more easily move from one group to another.

One kind of help is already coming. An Associated Press article in the January 3, 1994, *Fort Myers News Press* reported that the State Department of Transportation (DOT) was planning an underpass under State Route 46 in an area where many bears have been killed while trying to cross the busy road. According to the article, Jayde Roof, a trapper with the GFC, was attaching radio transmitters to bears so that he could monitor their use of the new underpass.

Underpasses were already in use in sections of Alligator Alley, now I-75. They had been built to save the endangered Florida panther. Gary Evink, DOT Manager of Environmental Services, said, "Road kills are significantly reduced." A November 25, 1993, *News Press* article, commenting on the Alligator Alley underpasses, said, "Wildlife tunnels make the road safer for most animals—although athletic bears sometimes are killed because they prefer to scale a barbed-wire fence and try to cross the highway."

Biologists measure tranquilized bears.

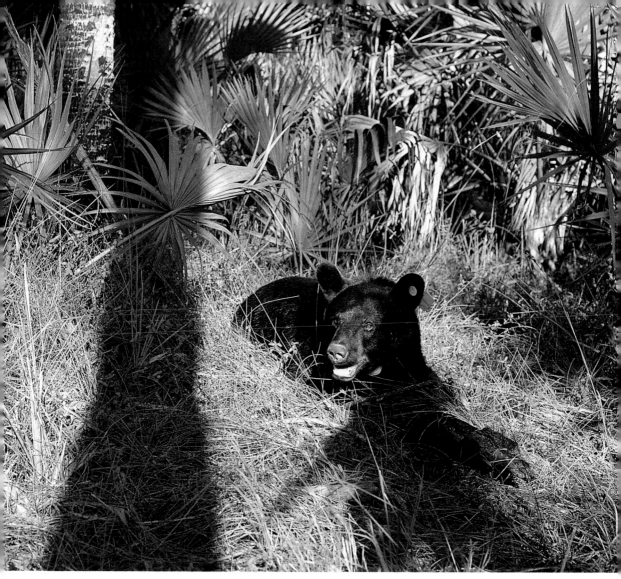

Pines and saw palmettos provide good bear habitat in Florida.

In spite of an "athletic bear" or two, these underpasses have proven successful in saving both animals and the people who might be injured in animal-car accidents.

Photographs taken by remote-control sensing cameras showed an encouraging assortment of creatures taking advantage of the

underpasses. Striding through them were opossums, bobcats, white-tailed deer, panthers, an alligator—and a man on a motorcycle who didn't belong there.

Hopefully, the bears will soon begin to parade through the new State Route 46 underpass that their human friends are having built for them.

A wildlife underpass along I-75 in Collier County, installed to help the endangered Florida panther. It is hoped that underpasses for bears will prevent many accidents.

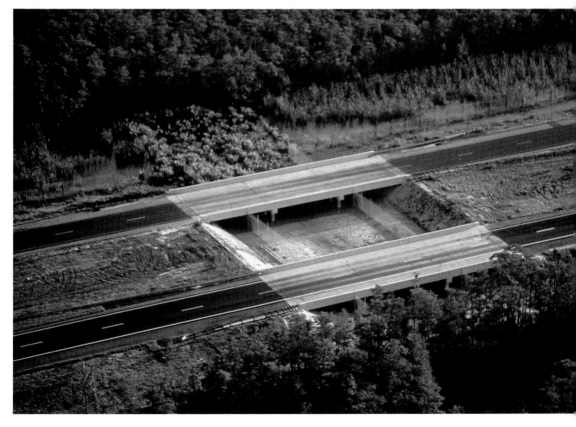

8
THREATENED

THE BLACK BEAR SHOWS ITS INTELLIGENCE BY STAYING AWAY FROM HUMANS most of the time. Sometimes, though, it gets into trouble by doing what comes naturally. It has a big appetite and when people leave garbage or food of any kind outdoors, a passing bear will happily eat it. Soon the bear may associate people with food and lose its fear of humans. Then it is likely to become too friendly, as one did in the following case.

A restaurant located near a woodland deposited leftover food in a large garbage can behind the building. A bear, led by its strong sense of smell, discovered this treasure, quickly removed the lid from the can, and began to eat. Drawn by the sight of a wild bear, several tourists lined up to watch and take pictures. The line grew longer.

An employee of the restaurant, eager to attract more customers, brought out another collection of food for the bear.

One of the watchers, realizing the possible danger, went to a

phone in the restaurant and called the conservation center, suggesting that they pick up the bear. Another person had already phoned the police.

Before the men in the conservation truck arrived, with equipment to pick up the bear and move it to a place far away, two policemen came. Just then the bear walked toward a young woman in the lineup. One of the officers, fearing that the girl might be injured, quickly shot the bear.

This yearling black bear paid a short visit to the author's summer home in Canada. He did no harm, except to eat some of the Shasta daisies.

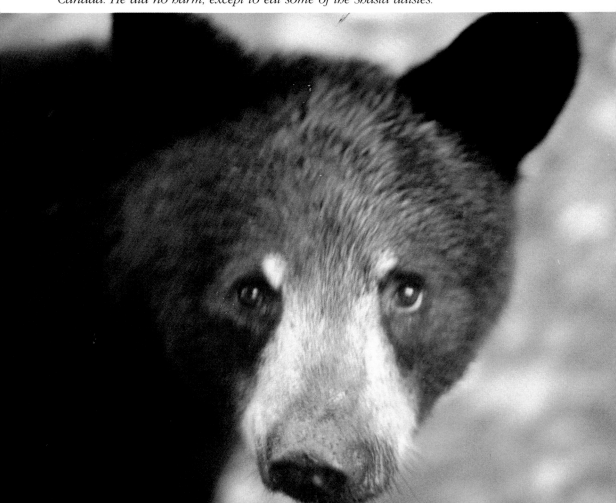

THE THREATENED FLORIDA BLACK BEAR

People all over the area were upset that the bear had been lured to its death by the food. Incidents such as this have made people realize that it is not kind to the bears to feed them and that it can be dangerous for humans.

Bears are also attracted to bee yards. They eat the honey, the bees, and the larvae, the early form of the bees. The visit of a bear is expensive for the beekeeper, and may lead to death for the bear. An electric fence around the bee yard usually keeps bears away, but this, too, is costly.

The Florida Game and Fresh Water Fish Commission (GFC) wanted to help the beekeepers and the bears. They sent out 1,608 questionnaires to beekeepers. Many of them answered the ques-

A bee yard protected from bears by an electric fence.

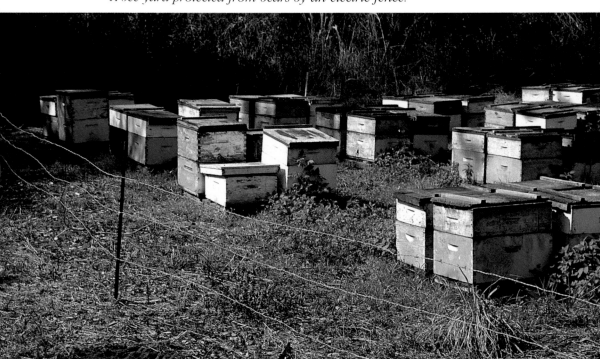

tions and sent in their answers. The GFC learned that the full-time beekeepers had more trouble with bears than the ones who kept bees part-time or for a hobby. In central and northern Florida, the bears came after the honey most often in spring. In southern Florida, the bears visited bee yards off and on all through the year. The survey also showed that the cost of having electric fences was less than the money the beekeeper would lose by not having them.

Bears are also attracted to chicken coops, pigpens, and vegetable gardens. In all cases, the electric fence is one solution. However, if the bear has had a taste of the food inside the pen before the electric fence was put up, it may go through, no matter what the pain. Sometimes bears are killed by angry farmers.

When wild food is plentiful, bears eat that and leave the farms alone, but the wild lands are turning into cities and farms. The forests, which for thousands of years were homes for the bears, are being cut down for condos and golf courses.

A fairly new danger has arisen for black bears. A profitable Oriental market for bear gallbladders and paws has brought about commercial poaching over much of North America. Many Asians believe the gallbladders have medicinal value. They use the paws for bear paw soup.

Florida cares about its wildlife. Bear hunting is illegal throughout the state. Underpasses are helping to prevent many accidents that could kill or injure both humans and wildlife on the highways.

The recent study of the Florida black bear by the Florida Game and Fresh Water Fish Commission has uncovered a great deal of information about the life, needs, and abilities of this handsome, intelligent animal. Their studies have shown that breaking up large forests into smaller patches surrounded by human developments

and busy roads is the greatest single threat to the Florida black bear.

The black bear is a solitary animal that likes to live in a forest, eating natural grasses, herbs, and insects. If people do not attract the bear with food, it usually will be contented in its own private world.

The Florida black bear is a solitary animal that survives very well in forested areas.

58

This adaptable creature does not demand large ranges, and has proved it can travel many miles for food or mating. With all the work that the wildlife biologists are doing, it is hoped that the "threatened" listing for the Florida black bear will not need to become "endangered."

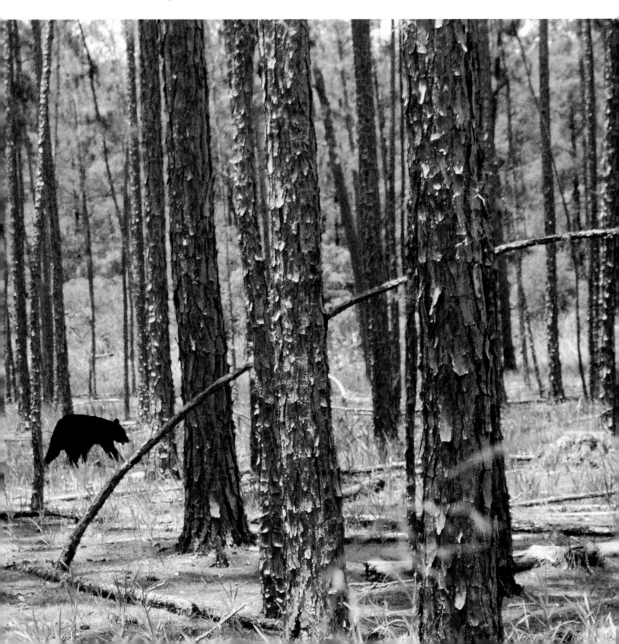

BLACK BEAR STATISTICS

The American black bear is the smallest of North American bears.

The black bear can run as fast as 35 miles per hour.

The black bear's short, curved claws help make it a speedy tree climber.

The black bear has an extremely strong sense of smell.

The Florida black bear is usually black with a tan muzzle and a white patch on its chest.

The Florida black bear is five to six feet long and about three feet high at the shoulder.

The average adult male Florida black bear weighs 250 to 600 pounds.

The average adult female Florida black bear weighs 150 to 300 pounds.

FLORIDA BLACK BEAR MILESTONES

1896 The Florida black bear was described as a subspecies of the American black bear and named *Ursus americanus floridanus.*

1950 The Florida black bear was given the standing of a game animal with a legal hunting season at the same time as the deer season.

1971 Bear hunting season was closed all over Florida except in Columbia and Baker counties and in the Apalachicola National Forest.

1974 The Florida black bear was listed as a threatened species except where it occurred as a game animal.

1978 Wildlife biologists doing research tried to find out if phosphate mining was having a bad effect on wildlife in Osceola National Forest. They went on to study black bears in Ocala and Apalachicola National Forests.

FLORIDA BLACK BEAR MILESTONES

1991 The Florida Game and Fresh Water Fish Commission (GFC) began research on black bears in southwest Florida.

1993 The Florida Game and Fresh Water Fish Commission closed the bear hunting season throughout Florida.

1994 It was estimated that there were only 1,000 to 1,500 black bears left in Florida. In south and central Florida underpasses were built for bears.

INDEX

INDEX